Spiritual MAZES & PUZZLES

SHELLY P. EMERSON

Copyright © 2017 Shelly P. Emerson.

All rights reserved. No part of this book may be used or reproduced by any means, graphic, electronic, or mechanical, including photocopying, recording, taping or by any information storage retrieval system without the written permission of the author except in the case of brief quotations embodied in critical articles and reviews.

This book is a work of non-fiction. Unless otherwise noted, the author and the publisher make no explicit guarantees as to the accuracy of the information contained in this book and in some cases, names of people and places have been altered to protect their privacy.

Scripture taken from the King James Version of the Bible

WestBow Press books may be ordered through booksellers or by contacting:

WestBow Press
A Division of Thomas Nelson & Zondervan
1663 Liberty Drive
Bloomington, IN 47403
www.westbowpress.com
1 (866) 928-1240

Because of the dynamic nature of the Internet, any web addresses or links contained in this book may have changed since publication and may no longer be valid. The views expressed in this work are solely those of the author and do not necessarily reflect the views of the publisher, and the publisher hereby disclaims any responsibility for them.

Any people depicted in stock imagery provided by Thinkstock are models, and such images are being used for illustrative purposes only.

Certain stock imagery © Thinkstock.

ISBN: 978-1-5127-7415-3 (sc)

Print information available on the last page.

WestBow Press rev. date: 02/20/2017

Ten Commandment Maze

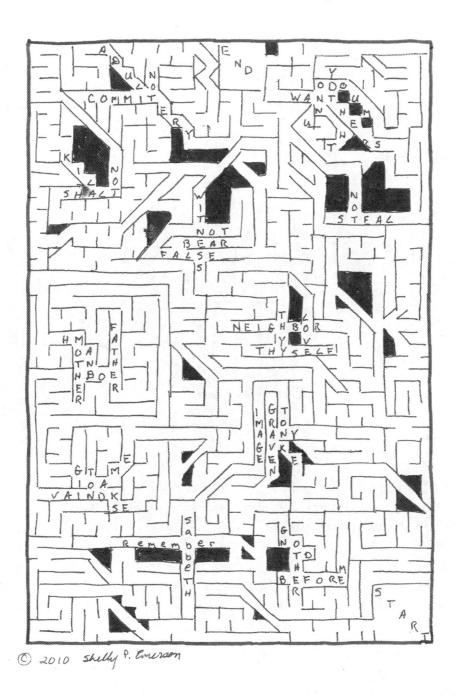

This is a Ten Commandment maze that also contains a crossword puzzle. You need to go through each of the 10 commandments to get to the end of the maze. Start at the bottom right corner and work your way up to the top center where it ends. Find the words of the commandments as you're going through the maze. If you'd like to look deeper into the 10 commandments see the scriptures in the maze.

Fruit of the Spirit Bowl

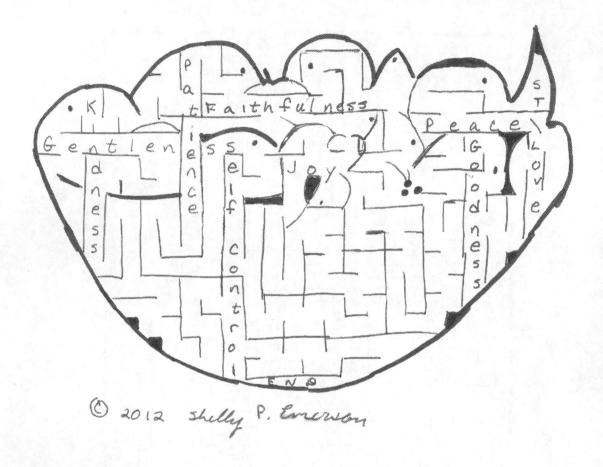

Fruit of the Spirit bowl maze contains the names of the spirit. The Fruit of the Spirit scripture: 22) But the fruit of the Spirit is love, joy, peace, longsuffering, Gentleness, goodness, faith, 23) Meekness, temperance, against such there is no law. Galatians 5:22-23

The maze begins at the banana at the top right corner of the bowl of fruit you need to go through each of the spirits to reach the end of the maze which is located at the bottom of the bowl. A little bit cross a word puzzle is in the maze! Write the names of the Fruit of the Spirit below:

1)	5)
2)	
2)	6)
3)	7)
4)	8)

America's Maze

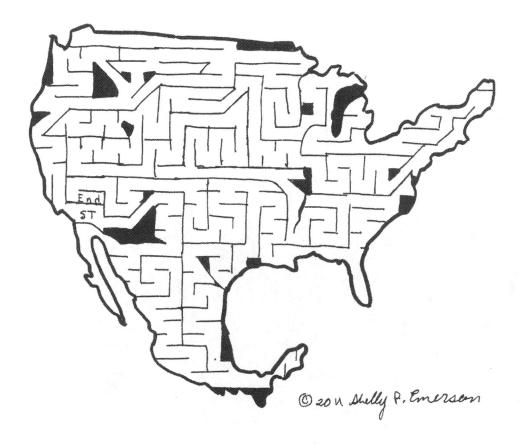

This maze of the United States of America & Mexico begins on the left side above California. It ends on the left side above where it started. You have the choice to go through America first then Mexico to get to the end or go through Mexico then America to the end.

Salan's Playground

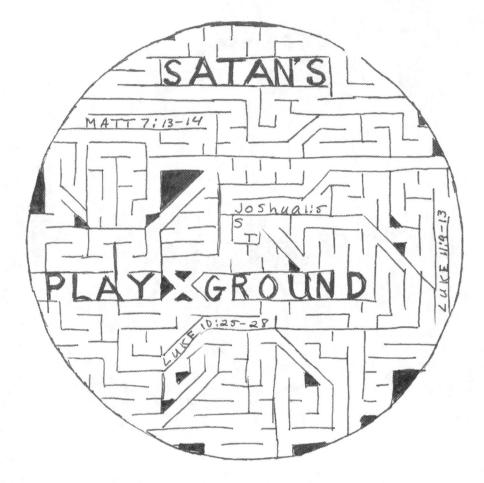

@ 2011 Shelly P. Emerson

We are living on Satan's playground. He is always playing around with everyone's life. That is why it is important to have a relationship with the Lord. That means having your Armor of Faith on! There is scripture you need to go through in order to get to the end. You can look up the scripture at any time. That will help you get stronger knowledge of God's Word and a closer relationship with Jesus. The maze begins in the middle of this ball and ends on the upper right side of the ball

Satan Out, Jesus In

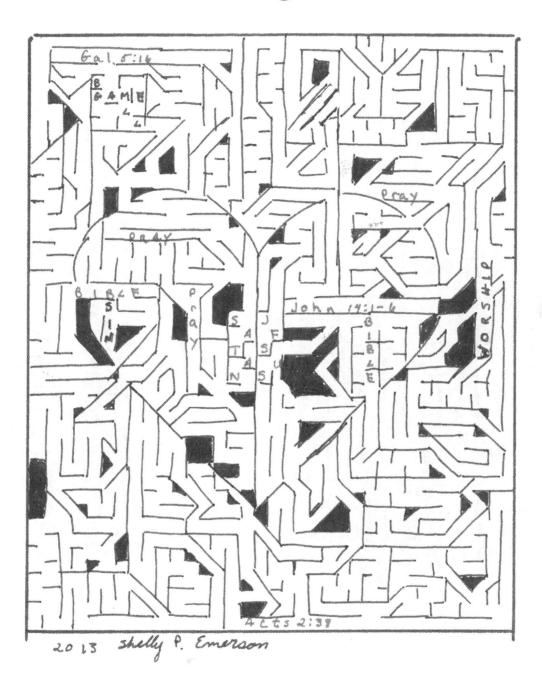

This maze begins in the center, on the left side of the heart. It ends on the right side. You have to go all the way around the heart to get to the end. This maze speaks of kicking Satan out of your life/heart and letting Jesus in and keeping Him in!

Jesus is Wailing at the Well

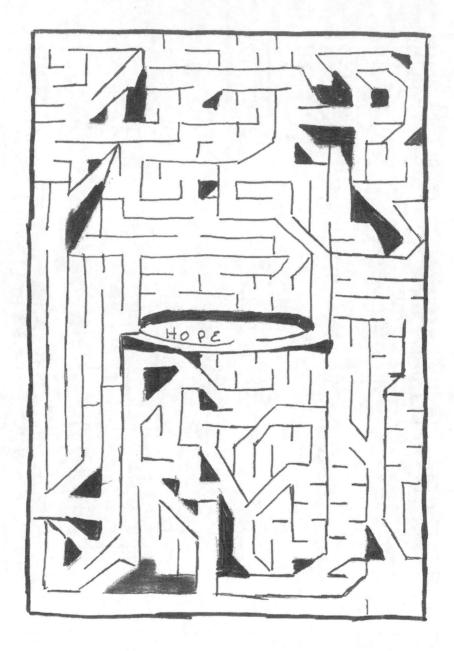

@ 2010 Shelly P. Emerson

This maze has to do with the story of Jesus waiting at the well for a woman who was covered with sin and was bound to hell. Jesus told her that what she needed was not in the well. It's the living water that she needed. That is what is needed for all those who drink the living water and will not thirst again. This story is in John 4:1-26. The maze begins at the bottom right corner and ends in the middle in the well of Hope.

American History

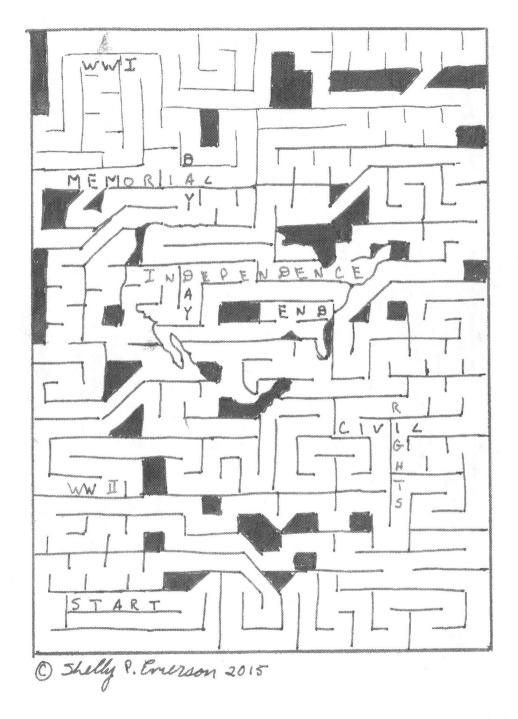

This maze has to do with the history of the United States of America. It begins at the bottom left corner, ends above Florida in Georgia inside the outline of America and Mexico. You'll need to go through: WWI, WWII, Civil Rights, Memorial Day, and Independence Day to reach the end.

Living in This World

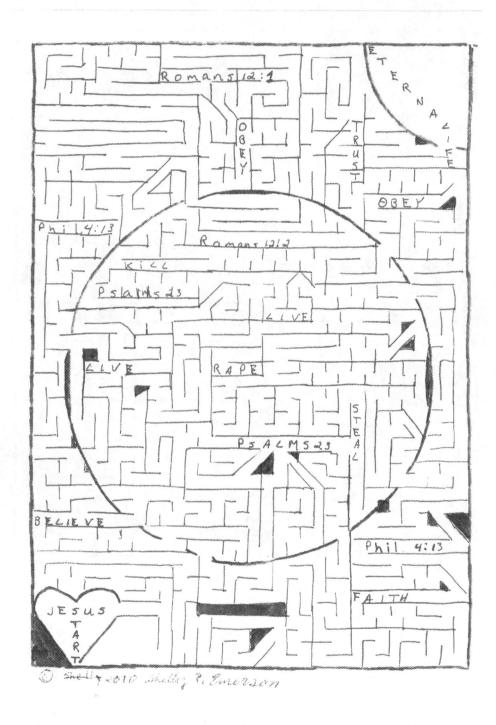

This maze has to do with living in this world, with Jesus in your heart. The maze begins in the heart at the bottom left corner. The end is at the upper right corner where it says Eternal Life. To get to the end you will need to go through scriptures and parts (Believe, Faith, Obey, Trust) of Christian living in this world do not get trapped in worldly things.

New Testament

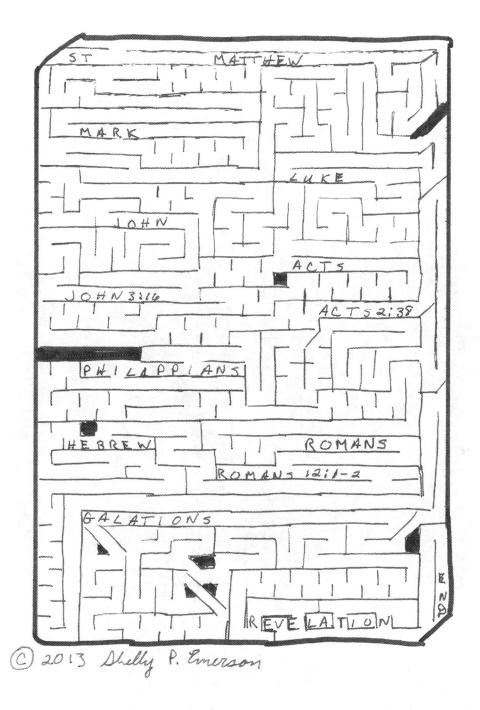

This is a New Testament Maze in the shape of a book. It begins at the top left corner. To get to the end of the maze at the bottom right corner you need to go through 10 books of the New Testament. Revelations is the last book of the New Testament you have to go through the book of Revelations to get to the end.

Praying Hands

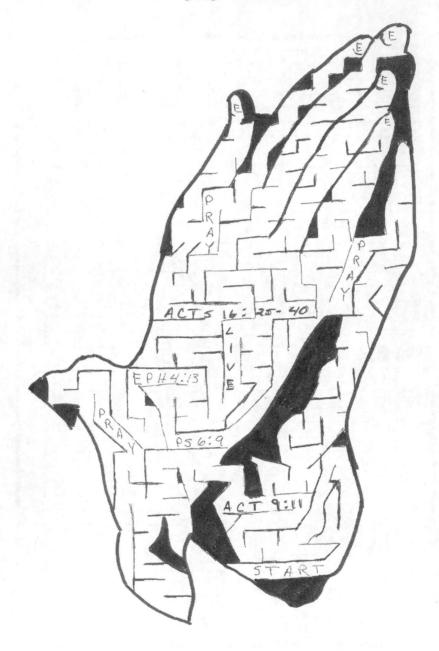

@ 2012 Shelly P. Emerson

This is a maze of praying hands. God knows what our needs are before we have the words to say them He knows what the answer is to our prayers. He has perfect timing as to when and where the prayers are answered. This maze starts at the bottom of the left wrist. There are five endings in this maze because there being 5 fingers on one hand. Prayer does not go out just one finger.

Crucifixion and Resurrection

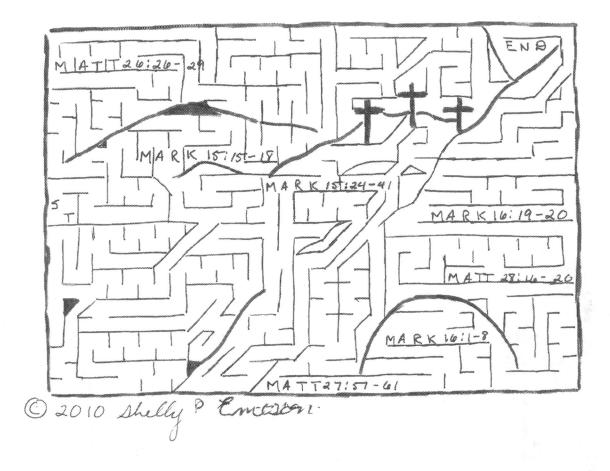

This is a maze about Easter and speaks of the Last supper, beatings, the Crucifixion, Burial, the Resurrection of Jesus Christ and His return to His Heavenly home. The maze starts in the middle on the left side and ends at the top right corner.

Life of Jesus

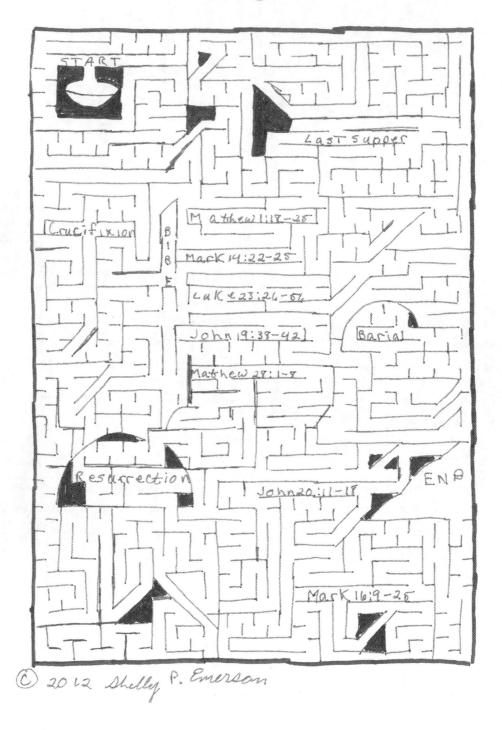

This maze has to do with when Jesus was born, and continues until to the day after His resurrection when He talked to his disciples. The maze begins at the birth of Jesus in a manger. The maze ends near the bottom right corner when he talked to His disciples before going back to his heavenly home.

New Testament Word Search

Matthew Mark, Luke, John, Acts, Romans, 1st Corinthians, 2nd Corinthians, Galatians Ephesians, Philippians, Colossians, 1st Thessalonians, 2nd Thessalonians, 1st Timothy, 2nd Timothy, Titus, Philemon, Hebrews, James, 1st Peter, 2nd Peter, 1st John, 2nd John, 3rd John, Jude, Revelations

																		,,,,,,,,,,,,,,,,,,,,,,,,,,,,,,,,,,,,,,,		,,,,,,,,,,,,,,,,,,,,,,,,,,,,,,,,,,,,,,,		,,,,,,,,,,,,,,,,,,,,,,,,,,,,,,,,,,,,,,,
D	J	À	M	E	S	J	M	С	J	D	Y	M	P	V	G	K	F	A	1	V	F	G
K	G	P	Т	J	K	L	В	J	С	0	L	0	S	S	Ι	A	N	S	Т	J	K	V
L	1	K	X	В	Z	Q	2	D	F	I	Н	Т	Н	K	С	S	J	M	Н	Z	E	Α
N	С	G	D	D	K	M	Р	J	С	F	M	N	Y	D	N	R	X	V	Е	N	Т	J
S	0	M	S	U	S	Α	Е	М	0	N	X	R	N	Y	S.	0	M	J	S	C	0	V
В	R	Т	L	U	В	Т	Т	Α	N	Н	В	V	S	Т	A	M	E.	R	S	Е	F	Y
Y	I	K	Т	G	Y	T	Е	N	X	U	N	J	С	K	J	A	U	X	A	J	Н	Т
K	N	I	K	Е	S	Н	R	Е	V	Е	L	Α	Т	Ι	0	N	Е	S	L	Т	Y	S
P	Т	S	F	M	D	Е	J	D	P	С	С	U	L	S	X	S	X	J	0	Α	P	Q
Y	Н	Е	В	R	Е	W	X	В	J	Н	N	Е	K	N	R	U	Ι	M	N	S	S	0
N	I	I	F	1	V	U	M	K	Z	K	E	V	F	Е	Н	G	I	1	I	J	L	D
Z	A	В	L	Т	S	В	V	S	A	R	T	S	K	S	V	T	P	J	A	С	2	M
С	N	K	R	Ι	J	K	K	0	Н	Ι	S	Н	I	K	2	Е	D	A	N	M	С	L
В	S	S	V	M	P	R	D	I	K	Z	G	A	L	A	Т	Ι	A	N	S	I	0	V
F	Q	В	W	0	D	I	0	R	V	N	J	Q	S	Е	N	0	P	J	I	D	R	N
J	G	Y	0	T	В	K	Α	Н	N	V	Z	J	R	V	N	S	Н	1	N	I	I	K
В	R	W	Q	Н	J	M	L	N	D	R	V	A	В	Н	Z	S	Ι	F	J	Q	N	V
E	J	J	В	Y	A	F	Y	Н	S	Н	N	M	0	K	В	M	L	Н	F	0	Т	Z
Н	В	F	U	G	K	Т	L	Р	J	D	Е	J	Н	A	M	U	Е	A	L	Ι	Н	K
V	S	М	S	D	В	U	D	W	Ι	J	3	С	S	U	A	Т	М	Н	С	W	I	N
N	С	2	Т	Н	E	S	S	A	L	0	N	I	A	N	S	S	0	D	L	R	A	D
Т	M	Y	A	С	L	W	L	Е	M	F	J	R	K	R	Q	0	N	Т	Q	J	N	K
X	R	D	U	Z	Х	G	D	I	P	Ι	Α	Н	U	W	P	F	J	R	M	D	S	С

Know God's Word

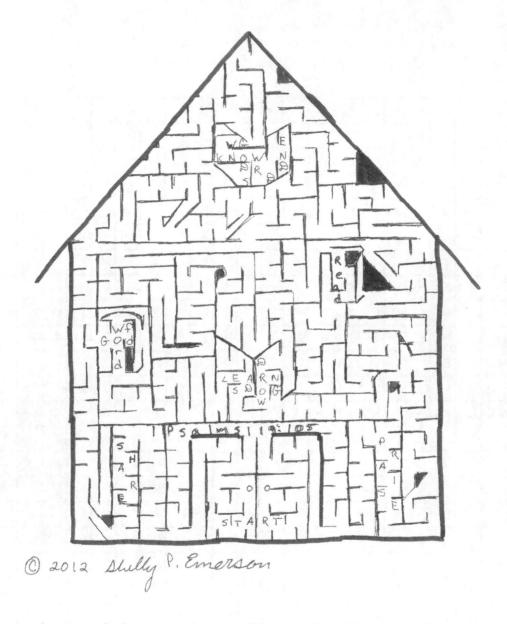

This maze begins at the bottom at the door of the church building and ends at the open book on the top. At the start you go through either the right hand door or the left hand door. The first and only scripture you will go through is Psalms 119:105. "Thy word is a lamp unto my feet and a light unto my path"

- 1) Why do we go to church?
- 2) What's the purpose of going to church?
- 3) What do we do when we attend to church?

American Flag History

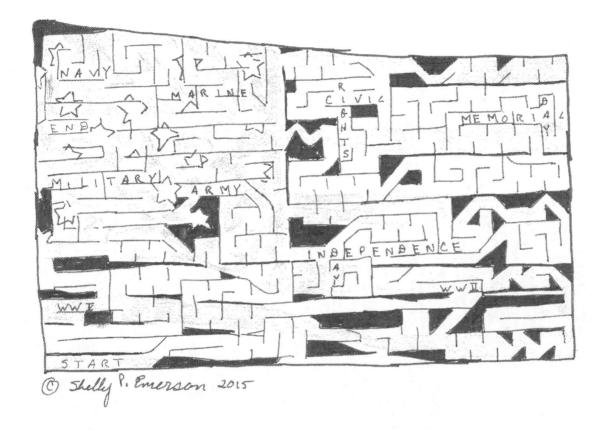

This maze is in honor of all men, women and counting dog veterans of the United States who in the military to protect our country. The stars in this maze represent the military members of the Marines, Navy, and Army. The gray and white lines represent what the military does when putting their lives at risk. The maze begins at the bottom left corner and ends in the middle of the box of stars on the left.

In God's Time

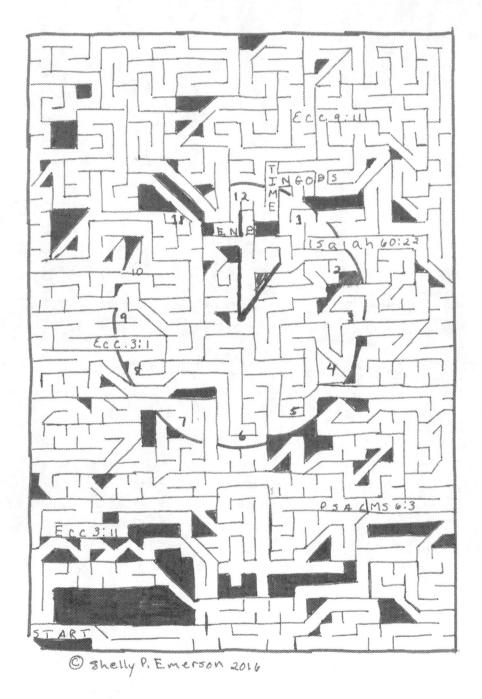

This maze has to do with God's Time. As to He has planned a time and place for things to happen in everyone's life. The scripture in this maze is about God's timing of when we have trials & trouble. The maze begins at the bottom left corner and ends at 12 O'clock on the clock in the center of the maze. To get to the end of the maze you'll have to go through the scriptures.

Paul and Silas

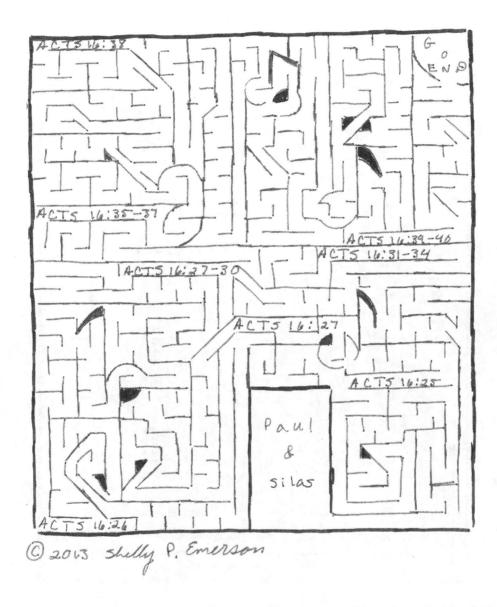

This maze has to do with the story of Paul & Silas in prison. They showed their faith in God by praying and praising God even though they were chained in prison. This shows the power in prayer. God heard them sing and pray, and opened the door of the prison, broke their chains and set them free. This maze begins at the center bottom of the door and ends at the top right corner.

- 1) Who broke Paul & Silas's chains?
- 2) What did Paul & Silas do when they were in prison that showed the faith in God?

Christmas.

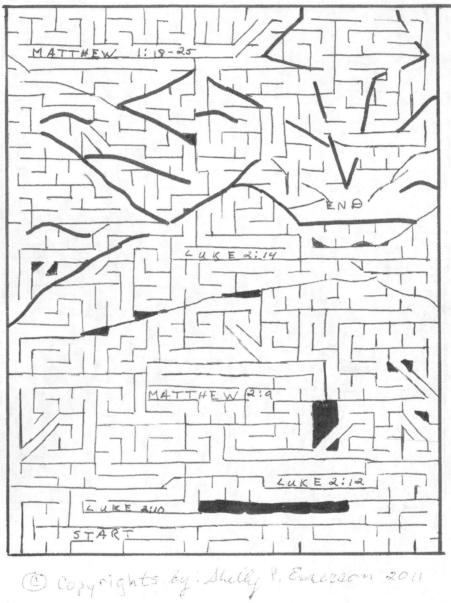

This maze has to do with the story of Christmas when the three wise men were told to follow the star which will lead them to the new born King. This has to do with the birth of Jesus Christ. The maze starts near the bottom left corner and ends below the golden star where Jesus was in the manger. You have to go through the scriptures listed in order to get to the end.

- 1) What is Christmas all about?
- 2) What did the wise men do?

The Woman at the Well

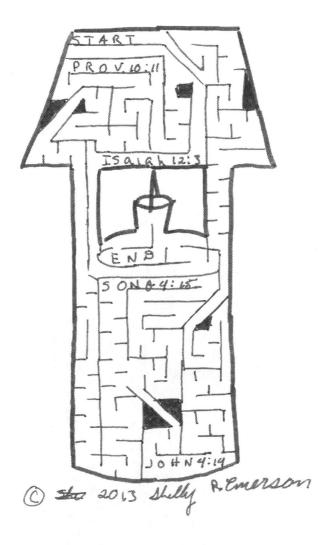

This maze has to do with the story of when Jesus was waiting at the well waiting for a woman who was covered with sin and was bound for hell. Jesus told her that what she needed is not in the well. It's the living water that she needed. That is what is needed for us all those who drink the living water and will not thirst again. This story is in John 4:1-26. The maze begins at the upper left corner of the shade of the well and ends in the middle in the well.

- 1) What is in the well that we need?
- 2) What did Jesus say to this woman?
- 3) Is Jesus still waiting at the well?

Shield of Faith

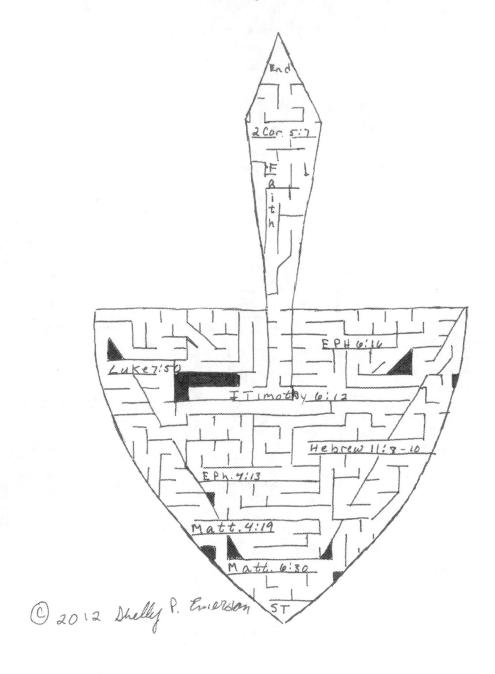

This maze has to do with the Shield of Faith and the Sword of Hope the armor of God. We as believers should wear God's armor at all times due to our battle we have with Satan, who is trying to stop us from following Jesus. The maze begins at the bottom of the shield and ends at the top of the sword. The scriptures listed are the steps for faith in Jesus. You must go through the scriptures to get to the end of the maze.

Old Testament Word Search

Genesis Exodus, Leviticus, Numbers, Deuteronomy, Joshua, Judges, Ruth, 1st Samuel, 2nd Samuel, 1st Kings, 2nd Kings, 1st Chronicles, 2nd Chronicles, Ezra, Nehemiah, Esther, Job, Psalms, Proverbs, Ecclesiastes, Song of Solomon, Isaiah, Jeremiah, Lamentations, Ezekiel, Daniel, Joel, Amos, Obadiah, Jonah, Micah, Nahum, Habakkuk, Zephaniah, Haggai, Zecharia, Malachi

Q	N	A	Н	U	М	Y	L	V	Χ	F	Z	Е	P	Н	A	N	I	A	N	J	S	Р	2	D
Е	В	K	L	I	В	E	С	2	S	A	М	U	Е	L	0	W	L	P	A	Z	Y	U	С	M
С	Z	N	Т	L	I	Q	W	L	G	P	V	Е	Н	С	В	R	В	S	I	S	Y	В	Н	W
С	G	R	R	N	В	J	Н	J	N	Е	Н	Ε	M	Ι	A	Н	G	Е	S	Т	Н	Е	R	В
L	H	M	Α	N	R	U	0	Р	M	Е	U	Н	0	V	D	X	Y	M	A	T	N	I	0	P
Е	Y	D	W	Ι	N	D	R	В	Q	Ι	G	R	В	D	Ι	D	S	X	I	0	N	R	N	H
S	U	N	V	M	Т	G	E	N	E	S	Ι	S	С	E	A	K	В	I	Α	0	D	P	I	A
I	G	M	Y	W	V	Ε	L	Z	I	K	F	В	U	U	Н	V	Y	Е	Н	В	S	L	C	В
A	2	K	I	N	G	S	K	A	М	0	S	N	D	T	J	W	Н	Q	V	A	Y	Е	L	A
S	P	Z	Е	С	Н	A	R	Ι	A	Е	Р	M	F	Е	Y	A	D	X	L	Е	D	V	Е	K
Т	F	L	В	Y	A	Ε	G	S	R	Y	D	Ι	F	R	N	P	W	M	Y	V	U	I	S	K
E	R	I	Z	В	T	Н	R	Ε	I	N	Е	Е	X	0	D	U	S	T	X	Z	T	T	J	U
S	E	Z	Ε	K	Ι	Е	L	Q	D	W	T	Y	J	N	Ε	G	U	Е	G	A	V	I	Α	K
Q	V	Y	S	I	В	Z	V.	L	T	1	С	Н	R	0	N	I	С	L	E	S	Ι	C	P	В
M	Z	G	A	М	A	U	W	Е	N	С	Е	J	N	M	K	X	Н	М	Т	S	В	U	R	A
Q	V	R	U	Т	Н	G	J	U	R	P	0	Z	E	Y	K	Y	1	K	I	N	G	S	N	Т
D	Α	N	G	F	С	V	G	M	W	E	T	С	M	R	U	E	Н	С	A	Z	S	С	D	W
В	Χ	С	V	D	G	Z	В	A	L	G	С	Α	G	V	E	Т	N	J	Х	В	M	С	S	G
Н	Q	V	F	Н	S	J	0	S	Н	U	Α	С	В	A	M	M	N	R	V	N	S	G	Ε	F
M	V	J	Z	N	J	F	D	1	M	Α	L	A	С	Н	I	V	Ι	F	Н	С	N	R	С	Y
V	Р	R	0	V	Е	R	В	S	В	M	S	L	A	M	Е	N	Т	Α	T	I	0	N	S	В
Т	K	V	U	L	S	0	N	G	0	F	S	0	L	0	M	0	N	W	Н	N	Т	Е	J	Y

God's Royal Kingdom

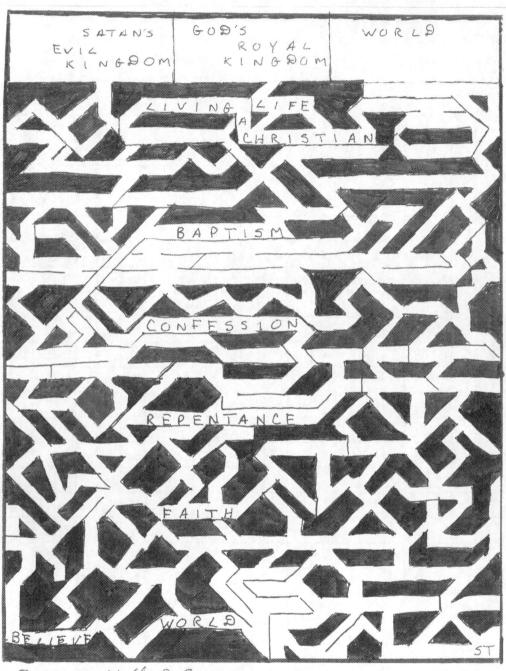

@ 2010 Dully P. Emerson

This maze shows the way to God's Royal Kingdom, there is only one way to God's Kingdom. It begins at the bottom right corner and the choice is to end at either: Satan's Evil Kingdom, God's Royal Kingdom, or this world. Going through the steps of salvation is the only way to reach God's Kingdom.

Three Starts One Ending

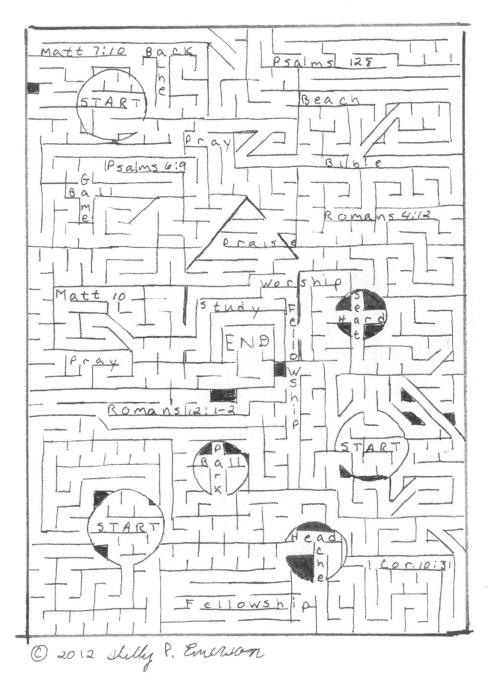

This maze has three starts, one ending. Satan is always using excuses to stop and pull people away from going to church to learn God's Holy Word, worship, & praise the Lord for what He has done for us. Start 1 is near the upper left corner start 2 is close to the middle right corner and start 3 is located near the bottom left corner The end of the maze is at the door of the church in the middle of the maze there are a few traps you will need to watch out for!

Bible Word Search

Old Testament: Genesis, Exodus, Leviticus, Numbers, Deuteronomy, Joshua, Judges, Ruth, 1 Samuel, 2 Samuel, 1 Kings, 2 Kings, 1 Chronicles, 2 Chronicles, Ezra, Nehemiah, Esther Job, Psalms, Proverbs, Ecclesiastes, Song of Solomon, Isaiah, Jeremiah, Lamentations, Ezekiel, Daniel, Joel, Amos, Obadiah, Jonah, Micah, Nahum, Habakkuk, Zephaniah, Haggai, Zecharia, Malachi New Testament: Matthew, Mark, Luke, John, Acts, Romans, 1 Corinthians, 2 Corinthians, Galatians, Ephesians, Philippians, Colossians, 1 Thessalonians, 2 Thessalonians, 1 Timothy, 2 Timothy, Titus, Philemon, Hebrews, James, 1 Peter, 2 Peter, 1 John 2 John, 3 John, Jude, Revelations

F	L	H	2	T	H	E	S	S	A	L	0	N	I	A	N	S	D	A	N	I	E	L	M
P	S	A	D	Q	1	W	K	Н	X.	P	J	Y	E	P	D	1	P	E	T	E	R	A	1
0	0	В	M	L	K	F	V	Н	E	E	T	D	U	F	R	T	J	0	В	0	T	L	C
В	N	A	G	Е	I	U	O	A	G	В	Z	C	В	J	1	0	Y	0	M	T	J	E	A
A	G	K	Y	1	N	H	Y	C	A	N	R	R	0	V	E	T	V	A	H	P	U	V	H
D	0	K	1	I	G	T	F	I	L	S	K	E	A	L	X	В	N	E	J	N	D	I	Z
I	F	U	C	L	S	N	A	M	A	J	N	A	W	F	O	S	W	В	R	T	E	T	E
A	S	K	Н	M	P	Y	H	T	T	K	A	A	T	S	D	S	H	J	0	В	L	I	C
H	0	G	R	Н	A	G	G	A	I	F	J	M	I	V	U	N	S	S	0	R	R	C	Н
p	L	T	0	L	F	R	X	U	0	0	V	S	Е	N	S	Q	2	I	Z	S	C	U	A
M	0	F	N	X	G	Z	K	C	N	В	N	X	S	S	O	Y	W	J	A	L	Н	S	R
С	M	2	I	J	U	D	G	E	S	D	X	S	P	H	prosed	L	E	M	0	N	J	U	I
V	0	S	C	E	C	C	L	E	S	1	A	S	T	E	S	K	A	1	P	Н	S	W	A
F	N	A	A	0	R	E	V	E	L	A	T	No.	0	N	S	L	V	S	Y	E	N	Y	J
X	E	M	I.	В	R	F	E	M	Y	Y	N	S	G	X	G	U	Z	A	S	N	G	0	R
P	H	U	S	D	N	I	I	Z	H	J	M	E	L	P	J	E	G	M	0	Е	N	I	3
Q	R	E	S	N	I	P	T	T	E	N	В	O	H	A	X	W	N	U	N	A	H	J	Z
Y	E	L	G	В	U	J	0	H	N	K	A	J	N	E	C	D	E	E	H	T	0	T	F
О	H	F	N	E	T	M	W	0	1	F	I	H	Y	0	M	I	S	L	S	H	D	J	1
I	T	P	I	P	I.	L	В	Н	R	A	Y	E	U	I	R	I	N	F	N	I	0	R	T
H	S	X	K	T	T	U	G	Е	Q	C	N	P	L	M	S	E	A	0	С	N	S	E	I
С	E	G	2	S	U	K	U	Е	R	T	H	S	D	Y	R	A	T	Н	R	T	Н	T	M
A	A	M	0	S	S	E	P	H	Е	S	I	A	N	S	V	I	I	U	M	H	F	E	0
L	Z	Е	P	Н	A	N	I	A	Н	S	P	L	G	C	T	В	T	A	Е	A	C	P	T
A	1	С	0	R	I	T	H	I	A	N	S	M	S	U	K	Н	G	N	H	D	T	2	H
M	p	H	I	L	L	I	P	P	I	A	N	S	S	J	E	R	E	M	I	A	H	H	Y

Fruit of the Spirit Tree

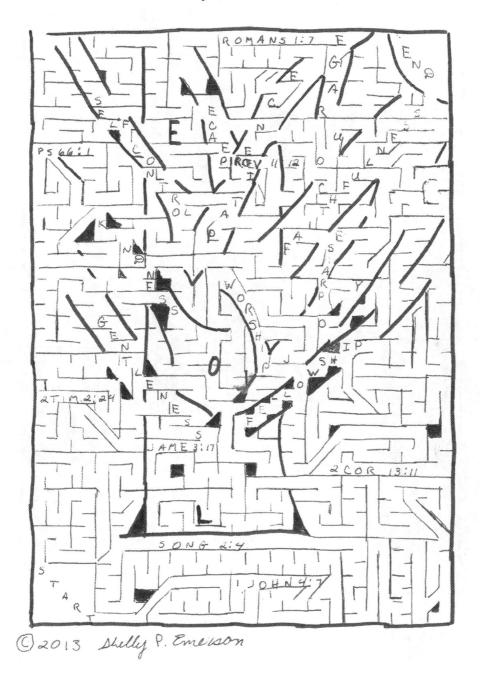

But the fruit of the Spirit is love, joy, peace, longsuffering, Gentleness, goodness, faith, Meekness, temperance, against such there is no law. Galatians 5:22-23

The Fruit of the Spirit Tree maze contains the names of the spirit. It begins at the bottom left corner. You will need to go through each one of the branches some of the branches have one or two of their own. The ends of the maze located at the top right corner in the sun

What Would Jesus Do?

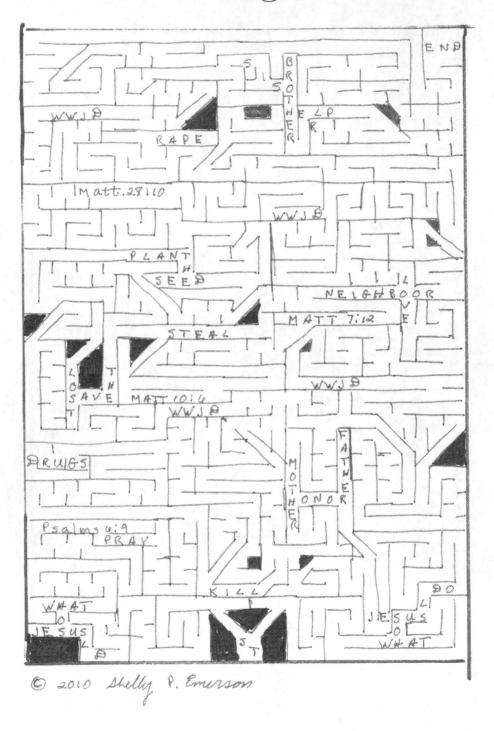

This maze is asking the question, "What Would Jesus Do?" It is a question that should be asked daily while going through life. A few traps are in this maze, and they are things that Jesus would not do. The maze begins at the center bottom. When you start, you can go either to the left or to the right. The end is at the top right corner.

Fruit of the Spirit Branches

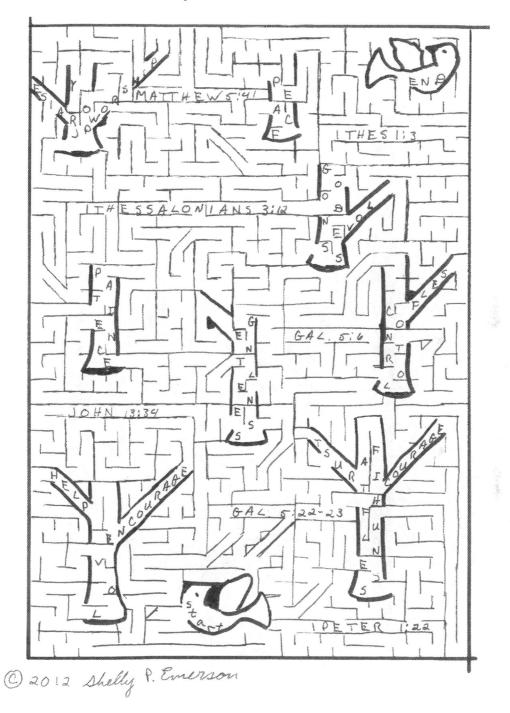

This maze has to do with the Fruit of the Spirit. There are eight spirits: Kindness, Love, Joy, Goodness, Peace, Patience, Faithfull, and Gentleness. The trees in this maze represent the fruit of the spirit some have branches. The maze begins at the dove in the middle at the bottom it than ends at the top right corner.

Guiding Light

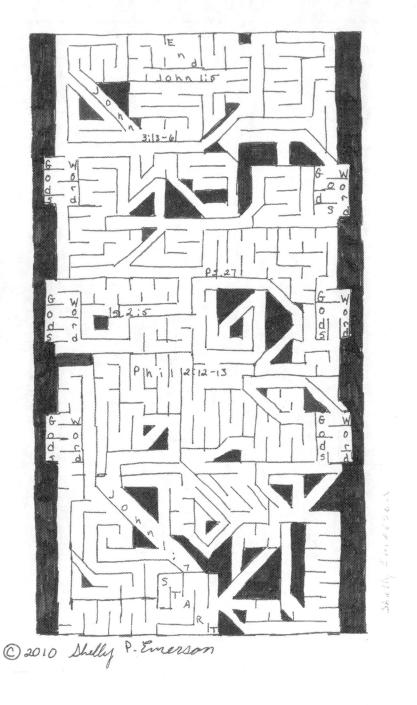

This maze Guiding Light has to do with God waiting at His throne at the end of the maze and Psalm 119:105. God's Word is the light unto our feet and our pathway as we walk through the dark. The maze begins in the middle bottom and ends in the middle top. There are some scripture needed to go through to get to the end. God's word is the lamp of our pathway in the daily life we live.

Power In Prayer

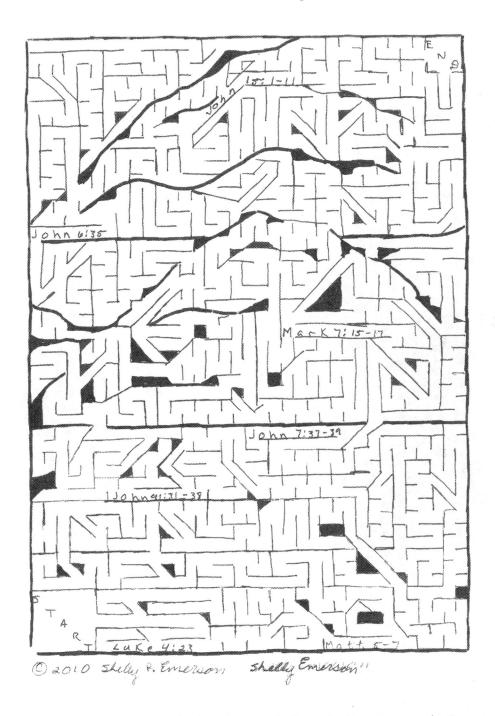

This maze has to do with Moses leading his people from the Egyptians to the Promise Land. He showed his faith in God, as the enemy was getting closer. God produced a tornado of fire to stop the enemy. Moses raised his hands asking God to let him and his people cross the river Jordan. Start at the bottom left corner, and end at the top right corner. You need to go through the scriptures in order to make it to the end of the maze.

Ocean of Life

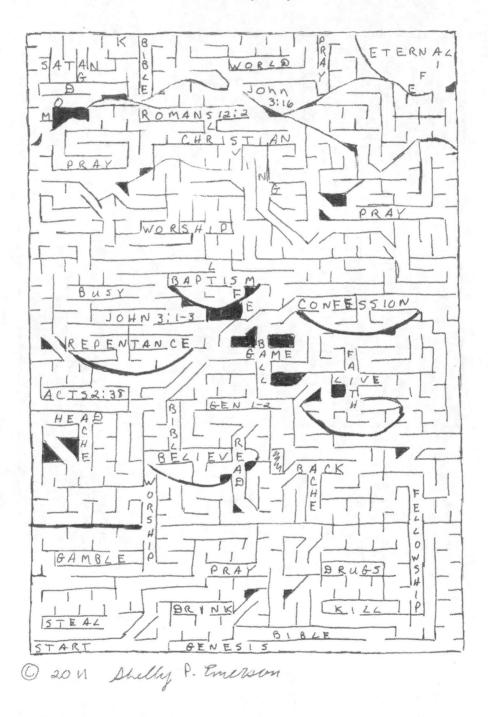

This maze has to do with being on the Ocean of Life with Jesus. It begins at the bottom left corner and ends on the upper right corner of Eternal Life. There are two entrances into the ocean of life. One entry is through Worship and the second is through Fellowship. Satan's kingdom is in the upper left corner of this maze. If you get in to Satan's kingdom, you can get back out through the bible and still get to Eternal Life at the end.

Heavenly Gate

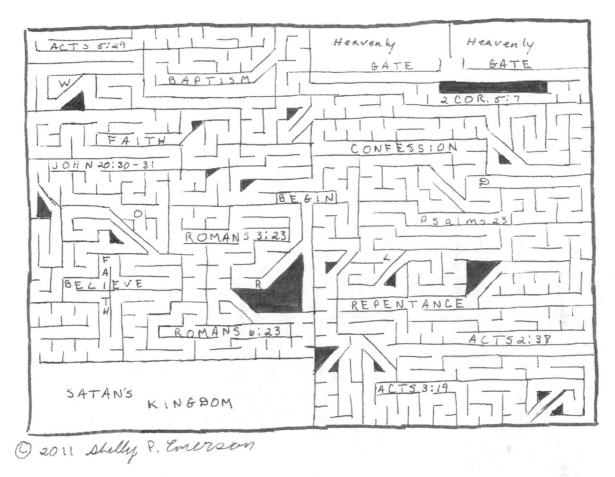

This maze is of the Heavenly Gate, where we will meet the saints who are waiting for us. This maze begins in the middle and can end at either the entrance to God's Royal Kingdom or Satan's Kingdom. There is only one way to enter the gate of Eternal Life

- 1) Why did Jesus sacrifice His life on the cross?
- 2) How many days was Jesus dead?
- 3) What does the resurrection show?

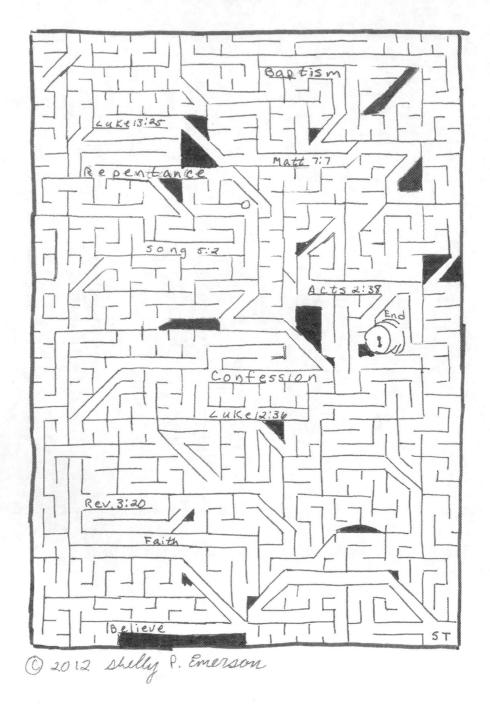

This has to do with the story of Jesus is knocking on the door waiting outside for your heart to let Him in to your life. The maze begins at the bottom right corner and ends at the door knob. The steps to Salvation in this maze need to be gone through to let Jesus into your heart

Moses Mountain

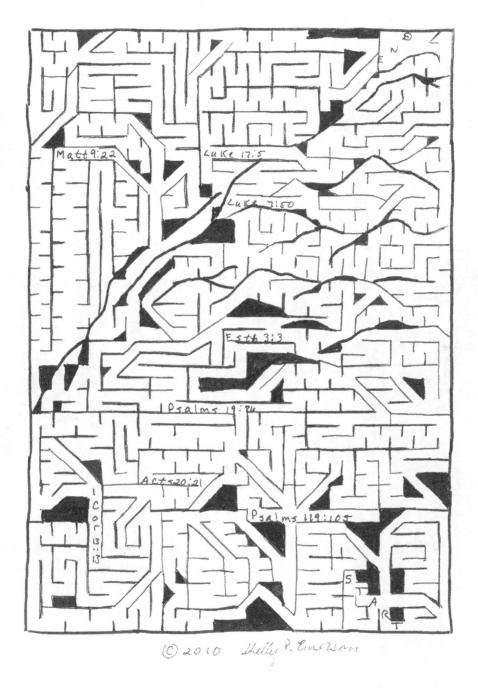

This maze has to do with Moses' faith in God as he traveled the desert sand, and climbed mountains. The maze begins at the bottom right. It ends at the top right, where Moses received water from the women after he protected them from men attackers.

God's Holy Word

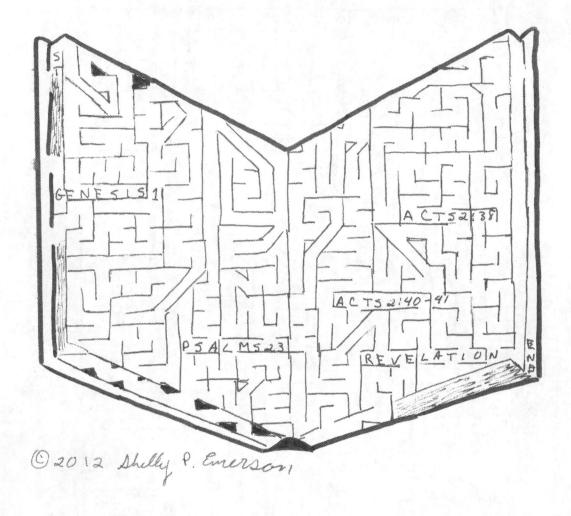

This maze has to do with God's Word though not all of the books of the Bible are in this maze, the first book Genesis and the last book Revelation are. It begins at the top left corner must go through the books of the Bible that are listed in the maze being that is first book and travel through. There is scripture in the maze ends at the bottom right corner. Need to go through the book of Revelations the last book of the bible, to reach the end.

Steps to Salvation

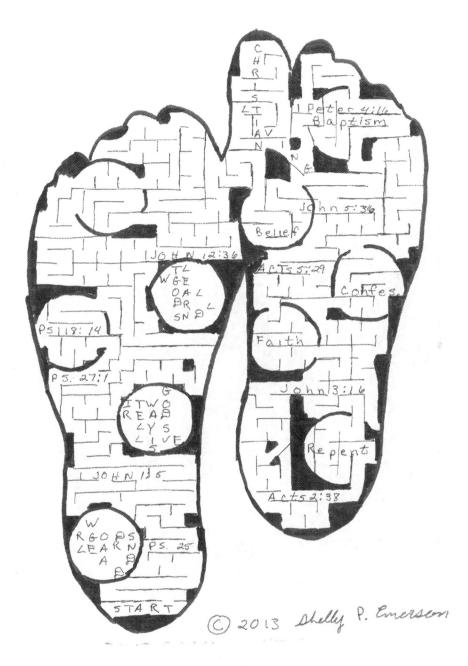

This maze has to do with a story about a man walking with Jesus on the beach. The man thought there was only one set of footprints. The maze begins at the bottom left heel and ends at the large toe at the top of the right foot. Some of the balloons in the left foot print are like word search puzzles. Some show scriptures you must go through the scripture in order to complete the maze. The balloons in the right footprint are the steps to salvation.

Armor of God

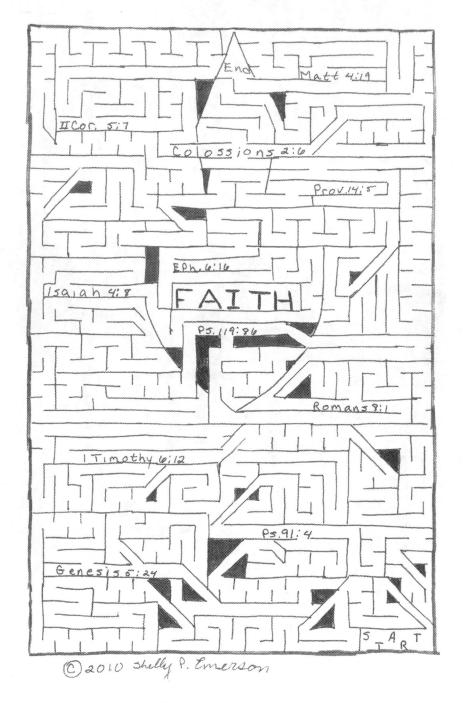

The Armor of God is the shield of faith and sword of hope for daily life. It is used to fight the good fight to eternal life. This maze starts at the bottom right corner and ends at the tip of the sword you need to go through scripture to make to the end.

Fruit of the Spirit

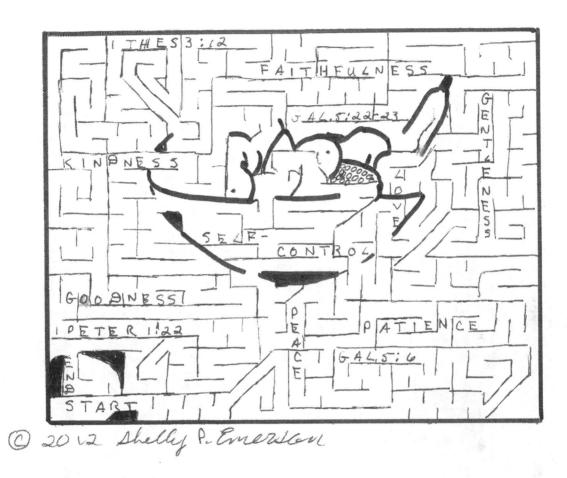

This maze contains a list of the Fruit of the Spirit it begins at the bottom left corner and ends above where it started. In order to reach the end, go through each of the spirits and scriptures.

List of Spirit Fruit

Jesus' Sacrifice

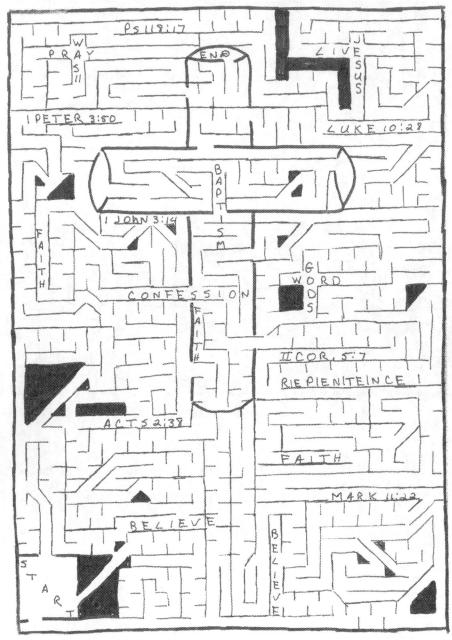

@ 2010 Shelly P. Emerson

This maze has to do with the blood Jesus shed on the cross for our sins. You must go through the steps of salvation to get to the end. It begins at the bottom left corner and ends at the top of the cross where Jesus sacrificed his life for our sins.

Worldly Life

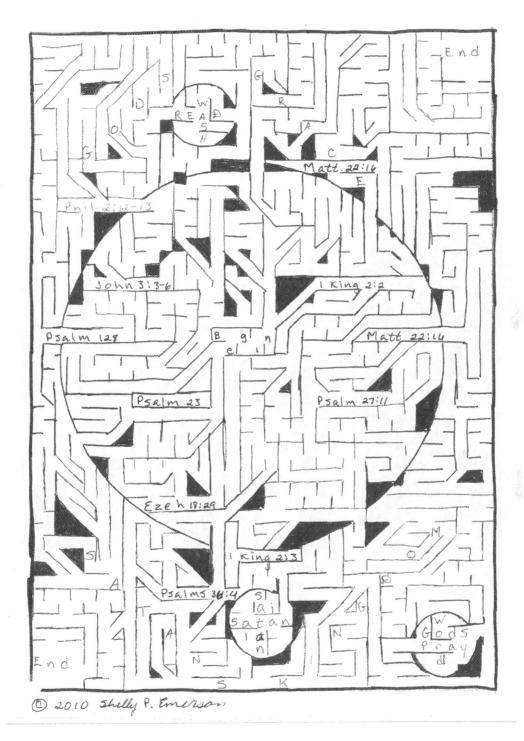

This maze has to do with living in this world. There is scripture throughout the maze. It begins in the middle of the globe. There is a choice of ending at Satan's Kingdom on the bottom of the maze or God's Grace at the top.

Surviving This World

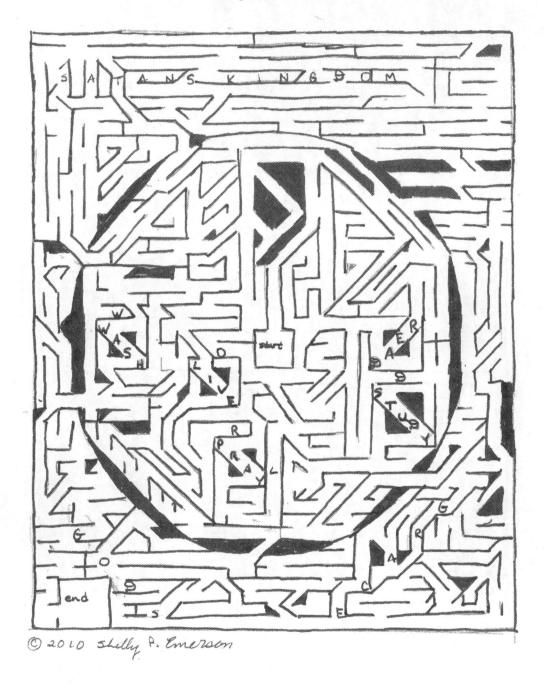

This maze has to do with surviving in the world, and not letting Satan pull you away from Jesus, the Son of God. The maze begins in the middle of the globe and ends at the bottom left corner going through God's Grace on the bottom of the maze.

Spiritual Mind

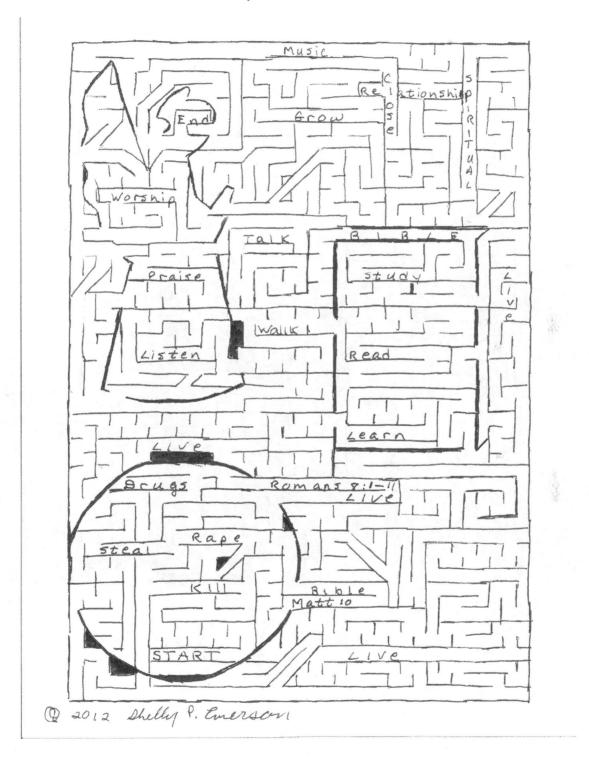

This maze has to do with having a Spiritual Mind in this world. It contains things of life that can be used to build a spiritual mind. It begins at the bottom left corner of the maze and ends at the top of the angle's head.

Key to Salvation

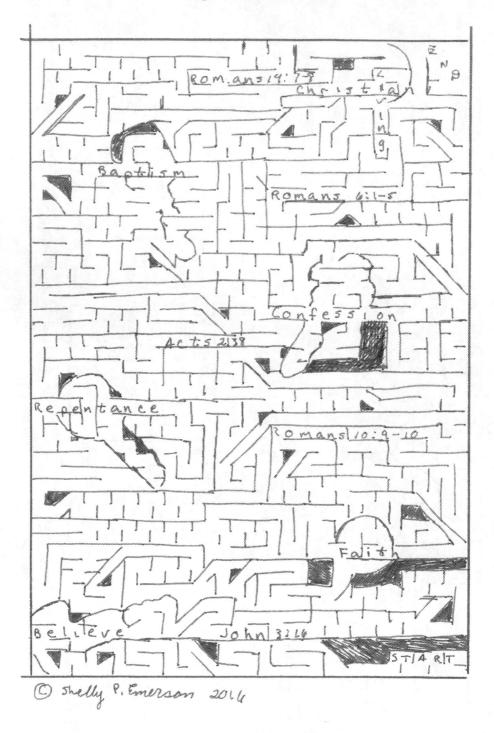

This Key to Salvation maze has to do with giving your life to Jesus, The Son of God. This maze contains the key route to Eternal Life. The maze begins on the bottom right corner and ends at the top right corner. To make it to the end of the maze, go through each of the keys that represent the path to eternal life in God's Royal Kingdom.

Last Supper

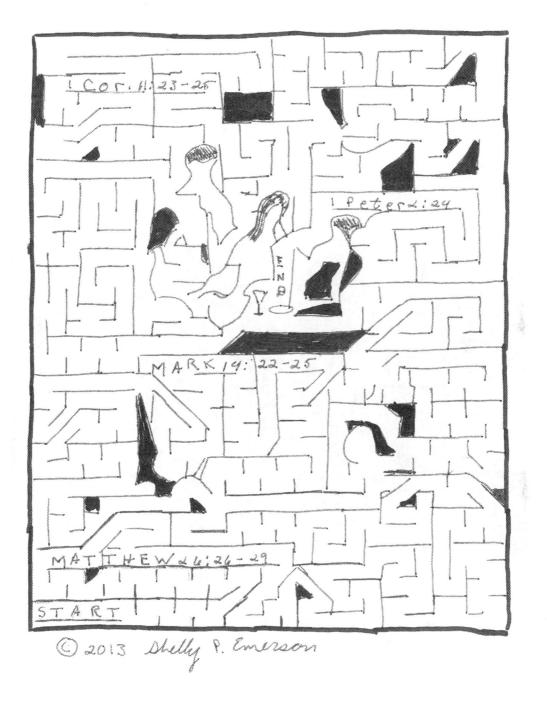

This is a maze of the Last Supper. Jesus had eaten with His disciples before He was taken to be beaten and crucified on the cross. He told them what the bread and the cup represented and that He would return in three days. This maze begins on the bottom left corner and ends in the middle of the table at the Last Supper.

Excuses of Daily Life

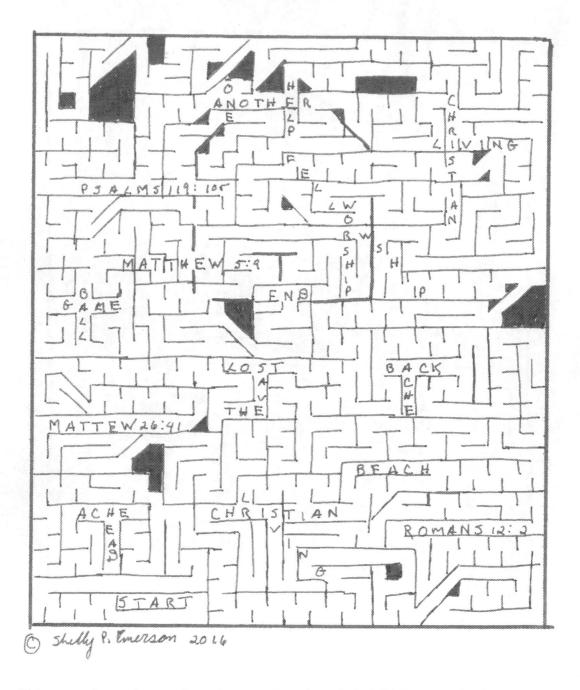

This maze shows the number of excuses heard in daily life. Satan is always trying to stop people from giving their life to God, and/ or live for Jesus. The maze begins at the bottom left corner and ends at the door of the church building in the middle of the maze.

Crazy Maze

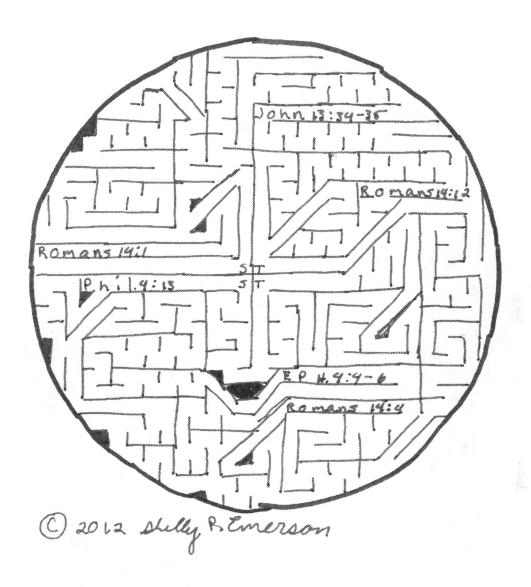

This Crazy Maze is a maze that actually never ends. It will land, but that is not the end. The theme of this maze is about knowing there is only one God, one Son and one Spirit. It begins in the middle with the choice of four corners, which is also, where it can land on the opposite side of where you started at or land where you start.

Mountain of Life

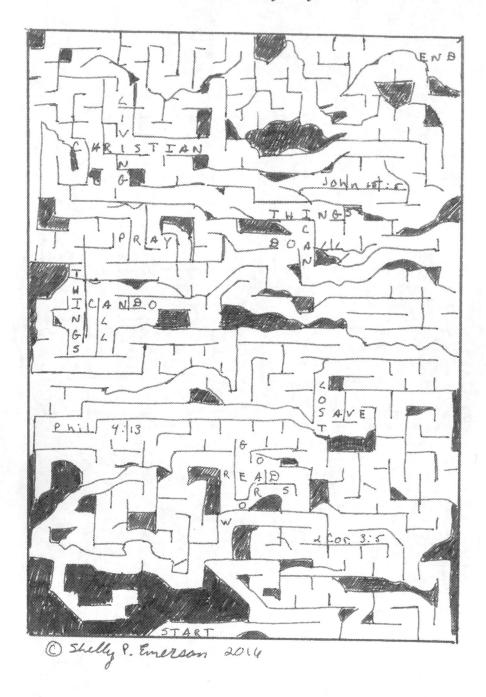

This maze has to with climbing the Mountain of Life on and facing the challenges in life. Philippians 4:13 says, "I can do all things through Christ who strengthens me." As we live in this world, everyone needs to keep the thought in mind. The maze begins at the bottom near the left and ends at the top right corner. In order to reach the end go through the scripture and the small word search puzzles inside the maze.

Only Through the Cross

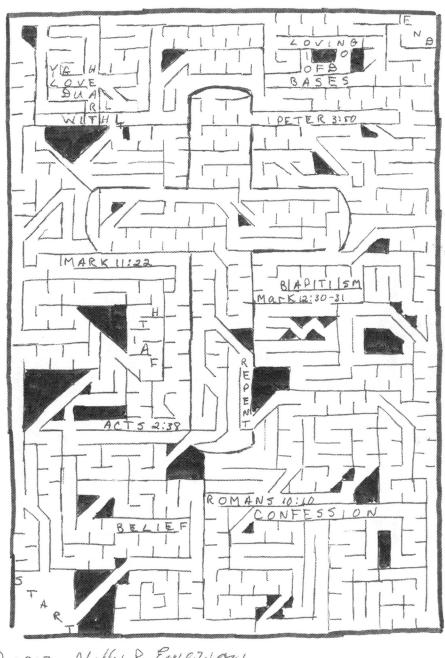

@ 2013 Stelly P. Emerson

This maze is about receiving the gift of eternal life by giving your life to Jesus. It begins at the bottom left corner In order to get to the end of the maze, which is located at the top right corner you must go through the cross. The way to reach the end you must go through each step of Salvation.

Old Testament

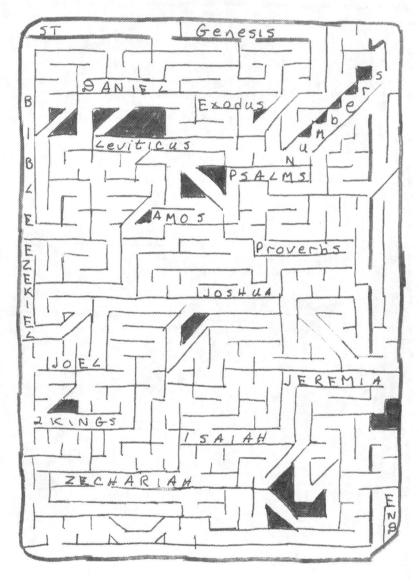

1 2012 Shelly P. Emerson

This is a maze of the Old Testament, though not all the books of the Old Testament are in this maze you need to go through each of the books of the Old Testament to get to the end. It begins at the top left corner and ends at the bottom right corner.

My name is Shelly Emerson, I was diagnosed with Epilepsy when I was 5 years old I became a born again Christian in 1975. Because of the Epilepsy, I've become creative with a variety of things. After giving my life to Jesus, I was told by my parents, "The Lord could be using you in some way," I was raised in a Christian environment and taught to stand firm on what I believe. I wrote several stories of experiences I've had throughout my life while attending GED writing, reading, & math classes, continued after I finished GED testing in 2011 and received certificate in 2012. I have no legal issues as to breaking the law or being put in to prison. I'll publish "Life Time Experiences" in the future, I've taken several artistic courses in college and am quite creative in a variety of ways such as greeting cards (holidays, birthday, and sympathy.), book markers; I'll recycle things after cleaning in to use able objects. Enjoy creating mazes & games it has been like therapy to me as to it helps me relax, encourages me to look deeper in to the Bible or American literature. I have visual & verbal multi-intelligence due to the music, sermons, & conversations I hear along with the movies, photos, & landscape I see because ideas of mazes or a craft project will come to mind. The publishing of "Spiritual Mazes & Puzzles" is my first time of publishing a book.

	lottes, al., al.